ALSO BY JAMAICA KINCAID

See Now Then

Among Flowers: A Walk in the Himalaya

Mr. Potter

Talk Stories

My Garden (Book):

My Favorite Plant: Writers and Gardeners on the Plants They Love (editor)

My Brother

The Autobiography of My Mother

Lucy

A Small Place

Annie, Gwen, Lilly, Pam and Tulip (with Eric Fishel)

Annie John

At the Bottom of the River

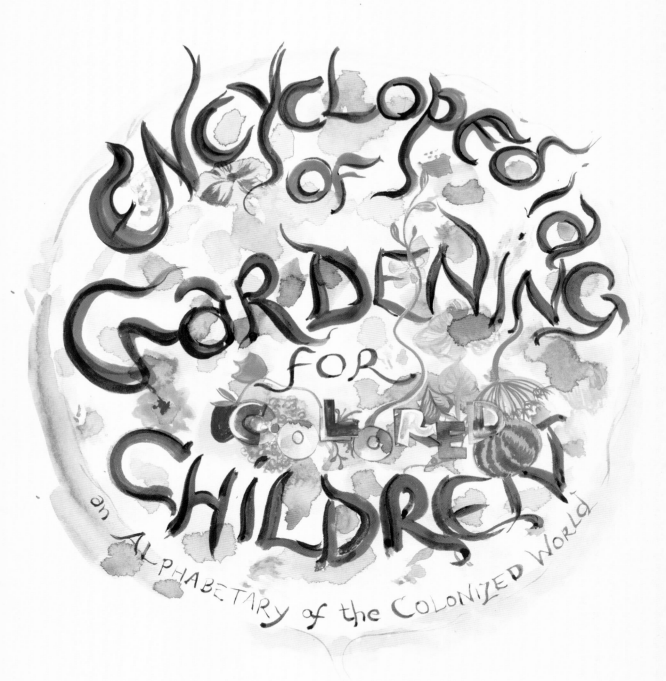

Encyclopedia of Gardening for Colored Children

an Alphabetary of the Colonized World

AN ENCYCLOPEDIA OF GARDENING FOR COLORED CHILDREN

JAMAICA KINCAID
and
KARA WALKER

FARRAR, STRAUS AND GIROUX
NEW YORK

Farrar, Straus and Giroux
120 Broadway, New York 10271

Printed in China
First edition, 2024

Grateful acknowledgment is made for permission to reprint lyrics from "Strange Fruit." Words and music
by Lewis Allan. Copyright © 1939 (renewed) by Music Sales Corporation. All rights outside the United States
controlled by Edward B. Marks Music Company. International copyright secured. All rights reserved.
Used by permission. Reprinted by permission of Hal Leonard LLC.

Library of Congress Cataloging-in-Publication Data
Names: Kincaid, Jamaica, author. | Walker, Kara, 1969- illustrator.
Title: An encyclopedia of gardening for colored children / Jamaica Kincaid ; illustrated
 by Kara Walker.
Description: First edition. | New York : Farrar, Straus and Giroux, 2024.
Identifiers: LCCN 2023003428 | ISBN 9780374608255 (hardcover)
Subjects: LCSH: Plants—History. | Plants—Color. | Plants—Identification.
Classification: LCC QK15 .K56 2024 | DDC 580—dc23/eng/20230824
LC record available at https://lccn.loc.gov/2023003428

Designed by Alex Merto and Gretchen Achilles

Our books may be purchased in bulk for promotional, educational, or business use.
Please contact your local bookseller or the Macmillan Corporate and Premium Sales Department
at 1-800-221-7945, extension 5442, or by email at MacmillanSpecialMarkets@macmillan.com.

www.fsgbooks.com
Follow us on social media at @fsgbooks

1 3 5 7 9 10 8 6 4 2

For Isla Noble Shawn

CONTENTS

AN ENCYCLOPEDIA OF GARDENING FOR COLORED CHILDREN

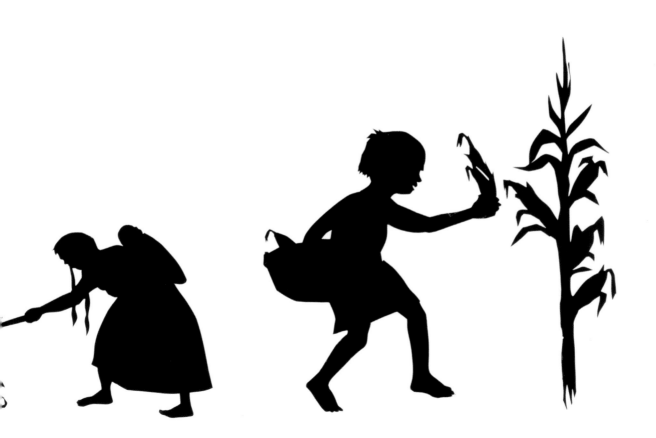

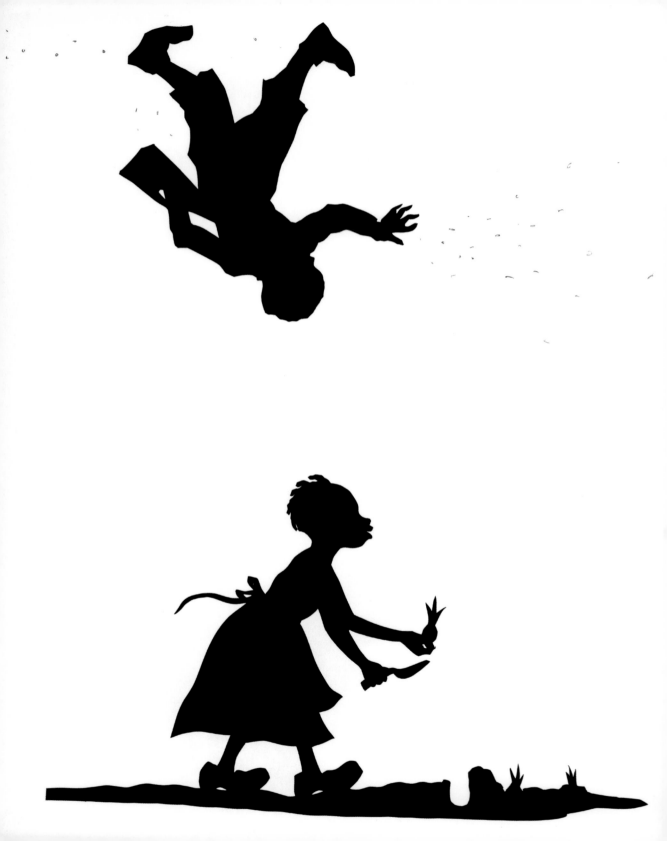

IS FOR APPLE (*Malus domestica*),* a member of the rose family (*Rosaceae*), famously thought to be the fruit the serpent gave to Eve and Adam to eat. It had been the one thing they were forbidden to do, eat that fruit, and after they did, they fell in love with the world around them, and understandably so, for they were in a garden. The fruit they ate could not have been the apple we know today, as that fruit is native to Central Asia. Most likely what Eve and Adam ate was a pomegranate. There is a legend that says there are as many seeds in a pomegranate as there are laws in the Torah, the Bible of the Jewish people, known to many others as the Old Testament.

*See **Linnaeus** for a discussion of the use of Latin names in botany.

A IS FOR APPLE AND ADAM, TOO. In the very first mention of human creation, God created man and woman in his own image. ("And God created man in His image, in the image of God He created him; male and female He created them.")

Adam and Eve as yet have no names. In the second creation story, God makes a garden, fills it with trees and animals, then makes a man and names him Adam. God allows the man Adam to name everything in the garden. Then perhaps God feels sorry for the loneliness of Adam so he causes him to fall asleep, and while he is asleep God removes one of Adam's ribs and makes a woman called Eve out of it, to be his companion. In the middle of the Garden of Eden, the place where Adam and Eve live, there are two trees: the tree of Life and the tree of Knowledge. God tells them they can partake of all the fruits in the garden except for the fruits from the tree of Knowledge. Like children everywhere, they do the thing they are told they should not do and eat from the tree of Knowledge. God, like most parents, is very angry and imposes a punishment on them, expelling them from the garden and making them homeless. It is a catastrophe that much later He regrets. In any case, they were asked to leave Eden through an eastern gate and told they could never return. And just in case they thought their banishment was a joke, because parents are notorious for changing their minds, an Angel was placed at the gate through which they had made their exit and he was given a twirling sword burning with a special fire; there he stands on guard to prevent them from sneaking in. A sad coda: Eve's female descendants, her daughters, are not particularly noted in her story. She seems to have never given birth to a woman of any note generation after generation.

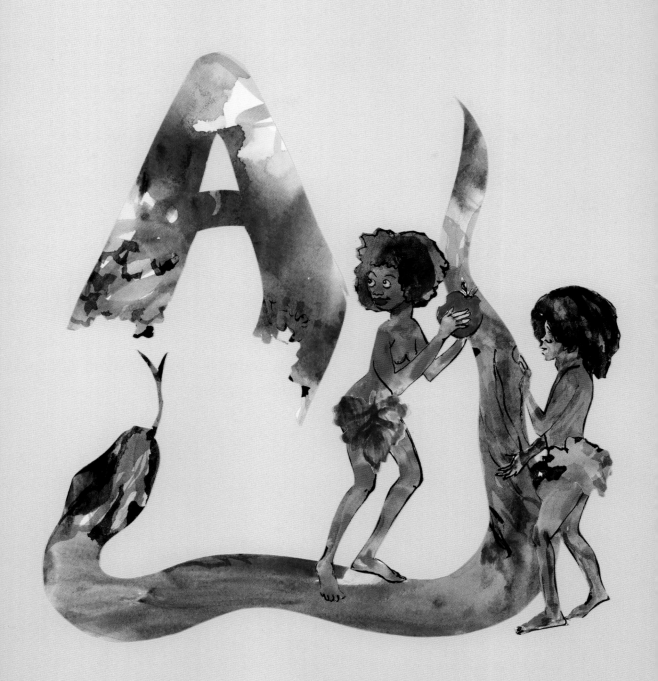

A IS ALSO FOR AMARANTH (*Amaranthus*). The amaranth is an herbaceous plant native to the southern parts of the American continent that had been home to and inhabited by the Aztec and Inca peoples. It was cultivated by them and was a substantial part of their daily diet. It was also used as a drink in rituals dedicated to various deities; for instance, it was an important part of ceremonies dedicated to the Aztec god Huitzilopochtli. When the Spaniards were not committing genocide against these peoples they met, who had made a comfortable life for themselves for generations and created extraordinary, glorious monuments to their civilizations, they were forcing them to abandon this source of physical and spiritual nourishment and replace it with barley, wheat, and other European grains. This, along with many other cruelties, led to the decline of the Aztecs and the Inca. The amaranth is now eaten all over the world, valued for its richness in protein and micronutrients. It is also grown as an ornamental plant in gardens, where it is prized for its vibrant colors and impressive height. Some gardeners, when reflecting on its history and its appearance in their garden as an ornamental, have a very fleeting debate within themselves over the ethics of growing food as an ornamental.

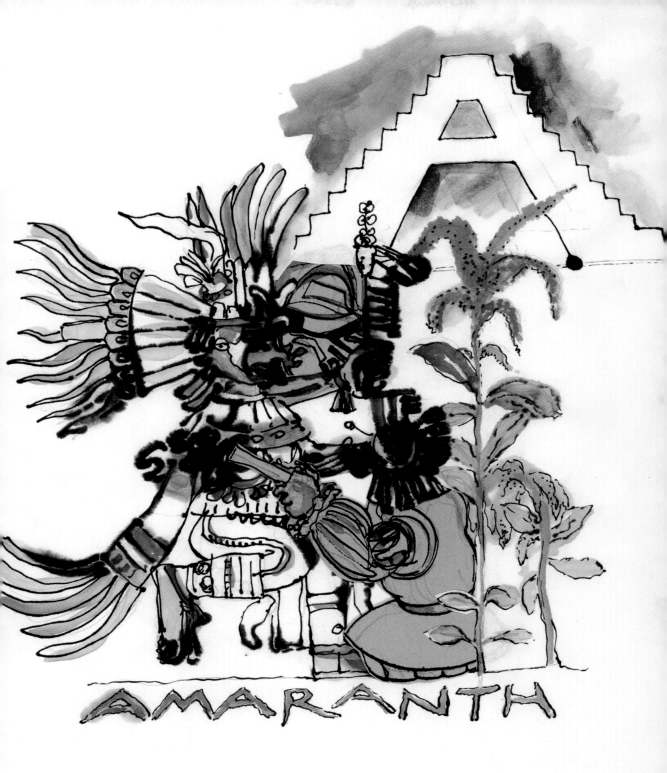

AMARANTH

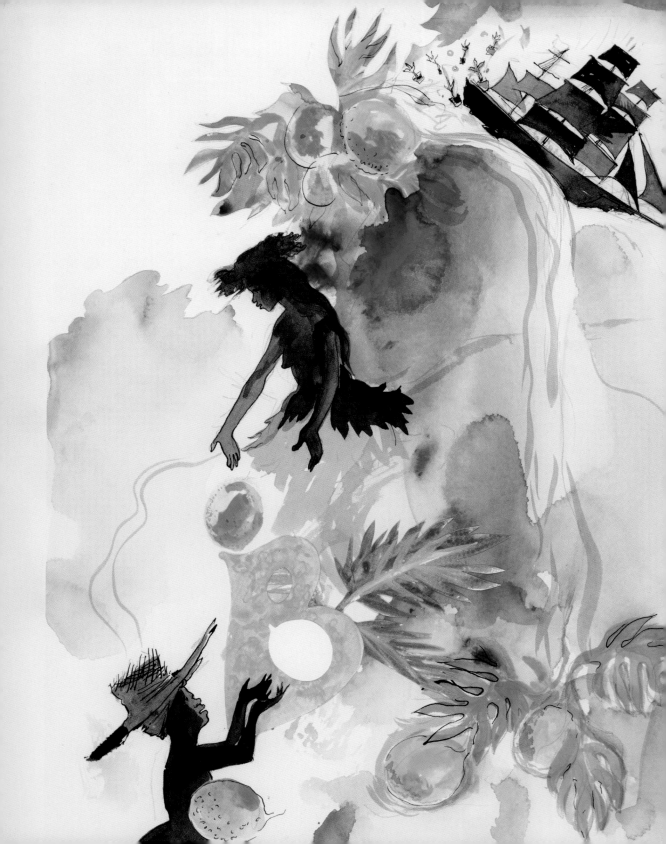

B IS FOR BREADFRUIT (*Artocarpus altilis*), which belongs in the same family as the *Morus* or mulberry (family name *Moraceae*), from whose fruits wine and jam can be made, and whose leaves are the sole food of the silkworm. The breadfruit is native to the Polynesian Islands, where it was found by Captain James Cook on his first voyage to that part of the world in 1769. Captain Cook was accompanied by the distinguished botanist Joseph Banks, who, more than any other single person, would influence the way many plants we're familiar with, some of them grouped into a category called the economic annual, were redistributed to various parts of the Earth that shared a similar climate to the ones from which they originated. This was all to the benefit of that bastion of evil known as the British Empire. The breadfruit was sent to the West Indies by Banks, first to the islands of St. Vincent and Jamaica. It was regarded as a cheap source of food for the enslaved people on the Islands. The slaves apparently were taking time from their labors to grow food to feed their hungry selves. The breadfruit was the cargo carried on the *HMS Bounty*, captained by Captain William Bligh, when his crew mutinied.

C IS FOR COTTON (*Gossypium*), a member of the mallow family (see **Hibiscus**), which also includes okra, hollyhock, and cacao or cocoa, from which is made chocolate. Cotton appears in regions nearest the equator. It has been used to weave into clothing for thousands of years. Adam and Eve could quite possibly have used it after they grew tired of using the leaf of the fig to hide their nakedness from each other. Cotton is one of the crops that played an important part in the industrialization and wealth of Europe. The community of people now disparagingly known as Luddites and portrayed as ignorant people opposed to the progress of the industrial revolution were really weavers of textiles who could not keep up with the vast amount of cotton produced by the enslaved people of African descent in the newly conquered islands in the Caribbean and the southern parts of North America. The mechanization of weaving textiles made the hand loom inefficient and unprofitable, and the hand loomers resorted to sabotaging the mechanized looms because they were losing a way to make sense of the world. Cotton, along with the sugarcane, was among the first commodities to make the world we now live in a global community.

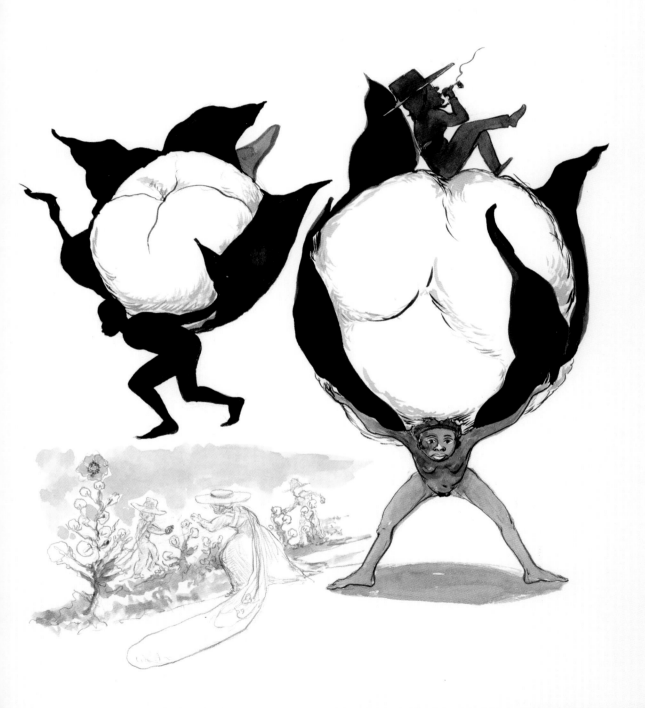

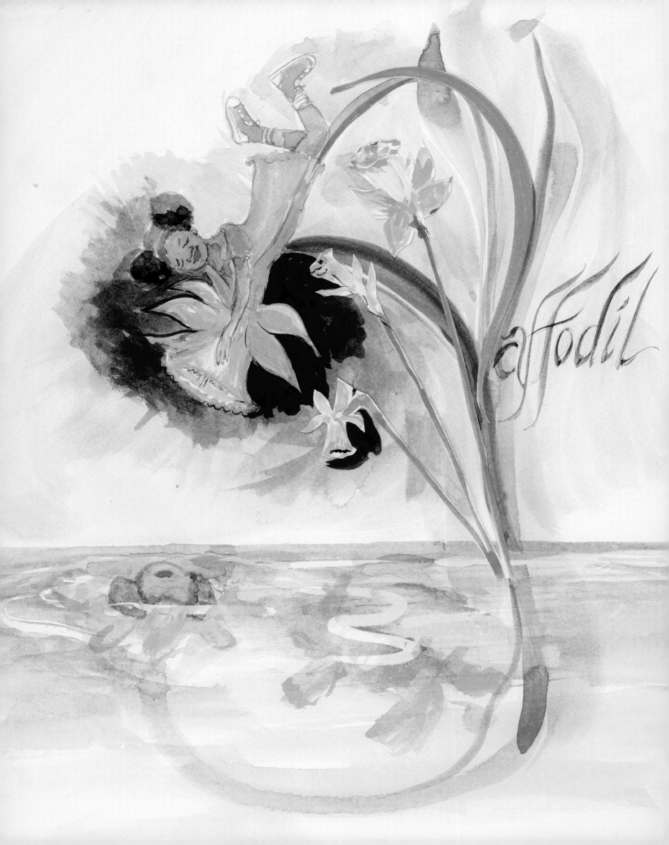

affodil

D IS FOR DAFFODIL, the common name for the *Narcissus*. It is native to the moist meadows and woods of temperate climates. Its appearance in the spring is eagerly awaited, its shy yellow color and slightly bowed blossom almost indicating gratitude for surviving the long dark days of the winter. The joy and abandonment of the burden that is everyday life a daffodil brings to an English person is commemorated in a poem by William Wordsworth, "I Wandered Lonely as a Cloud."

I wandered lonely as a cloud
That floats on high o'er vales and hills,
When all at once I saw a crowd,
A host, of golden daffodils;
Beside the lake, beneath the trees,
Fluttering and dancing in the breeze.

Continuous as the stars that shine
And twinkle on the milky way,
They stretched in never-ending line
Along the margin of a bay:
Ten thousand saw I at a glance,
Tossing their heads in sprightly dance.

The waves beside them danced; but they
Out-did the sparkling waves in glee:
A poet could not but be gay,
In such a jocund company:
I gazed—and gazed—but little thought
What wealth the show to me had brought:

For oft, when on my couch I lie
In vacant or in pensive mood,
They flash upon that inward eye
Which is the bliss of solitude;
And then my heart with pleasure fills,
And dances with the daffodils.

This poem became canonical in the education of children who were subjects of the British Empire. For the most part, these children were native to places where a daffodil would be unable to grow and so would never be seen by them.

E <small>IS FOR EARTH.</small> The earth you hold in your hand as you make a place to plant a seed is part of the Earth, our home, the planet on which we live. The Earth, our home, is five billion years old, impossible to imagine and yet true. Scientists, people who have studied this, have speculated that the atmosphere in which we humans, individual gardeners, now live is the result of one hundred million years' rain of toxic natural chemicals, so here we are. Before we came into existence, many other beings very different from us roamed our home. We only know of them through our determined search for their remains—a bone here, a skull there. The gardener walks the earth, which will eventually shrug us off, as it has done many times before with many things and beings that preceded us.

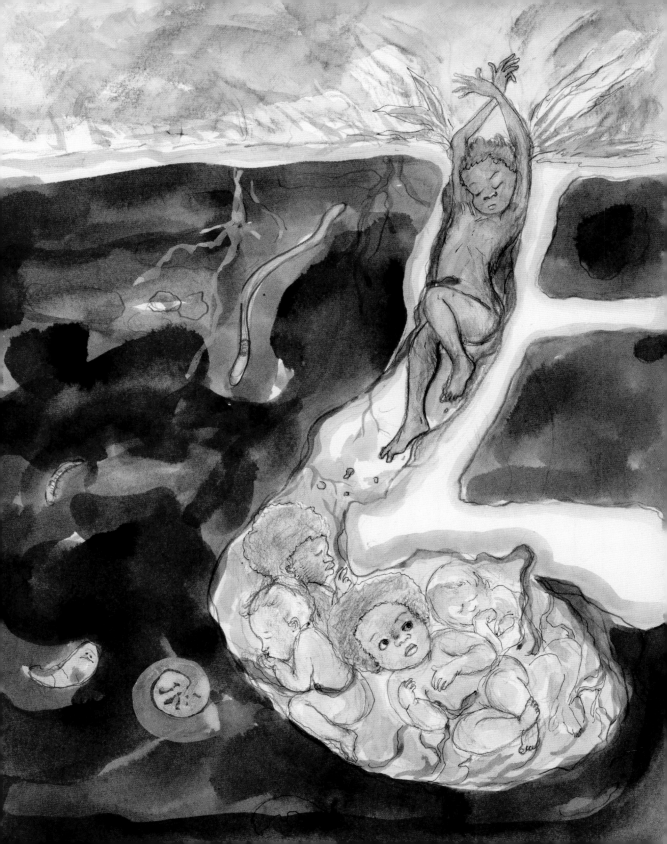

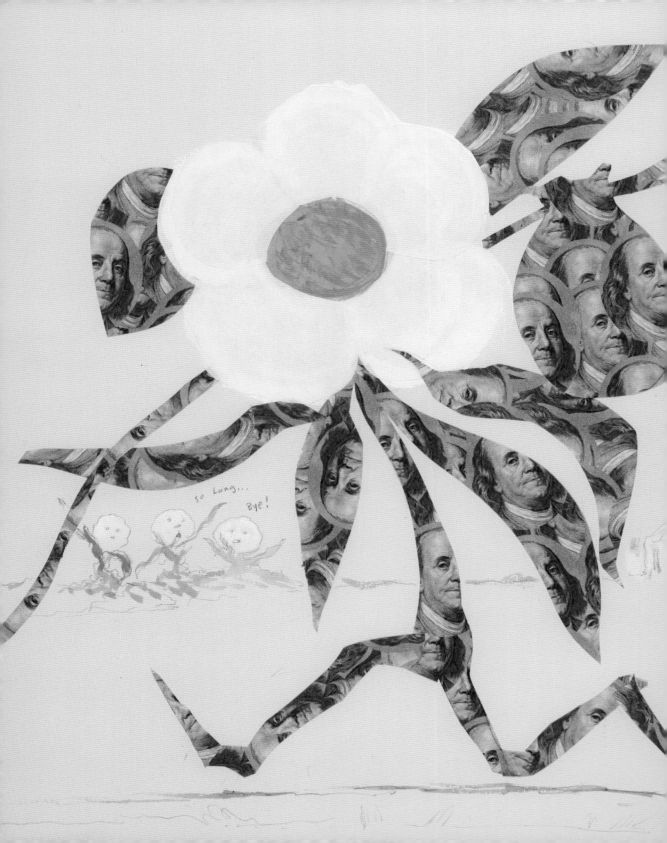

F IS FOR FRANKLINIA. *Franklinia alatamaha* is a deciduous member of the *Theaceae* family. The plant was named for Benjamin Franklin by his friend John Bartram, an American botanist and plant collector in Colonial times. Bartram was the botanist for King George III and the father of William Bartram, also a great botanist and writer. John and William Bartram found this plant growing on the banks of the Altamaha River in what is now called Georgia. The Bartrams traveled extensively in the southern part of what is now the United States. John corresponded with botanists from Europe, among them the notorious Carolus Linnaeus and Thomas Jefferson; William wrote a book called *Travels of William Bartram*, which is thought to have been a great influence on the English Romantic poets, in particular William Wordsworth. The Franklinia has never been seen again in its natural habitat since that sighting by Bartram father and son, and all the plants that exist today are descended from their collection of it.

G IS FOR GUAVA. The guava (*Psidium guajava*) is a fruit beloved by children who live in the area of the world known as the Caribbean and in nearby Venezuela. It bears beautiful white flowers that almost everybody completely ignores because the fruit to come is delicious to eat just picked from the tree when ripe. It can also be made into a beverage or a jam or paste that when cut into squares is a treat for a child going to or coming from school.

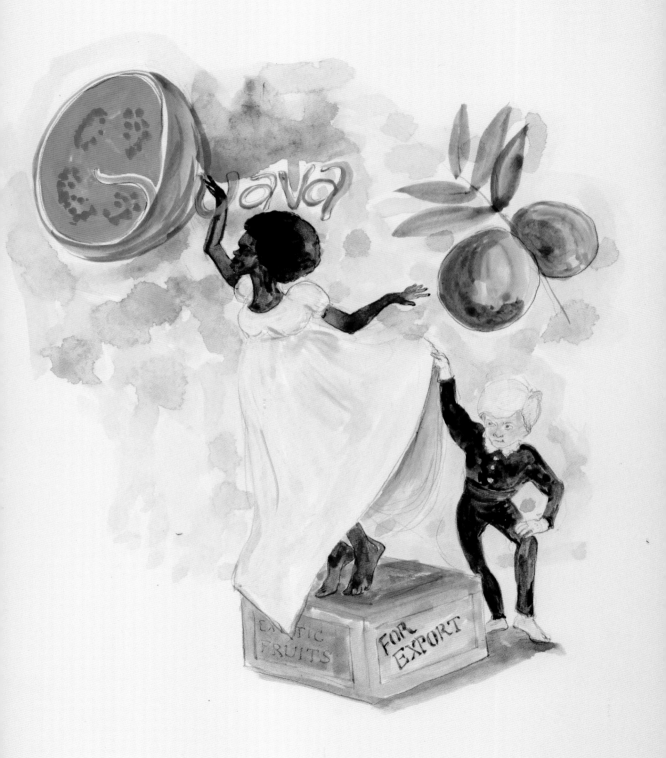

H IS FOR HIBISCUS, also a member of the mallow family (*Malvaceae*). There are hundreds of individuals in this family, including okra (*Abelmoschus esculentus*); roselle (*Hibiscus sabdariffa*), also known as sorrel in the Caribbean, where it is a traditional beverage accompanying the main Christmas dinner; cotton (*Gossypium arboreum, barbadense, herbaceum, hirsutum*); and hollyhock (*Alcea rosea* and *Alcea ficifolia*). To any child growing up in parts of the world conquered and tyrannized by Europeans, a form of the hibiscus (*Hibiscus rosa-sinensis*) will be a permanent fixture in her/his/their imagination, for this shrub, native to the tropical area of China, is the national flower of these many colonized countries.

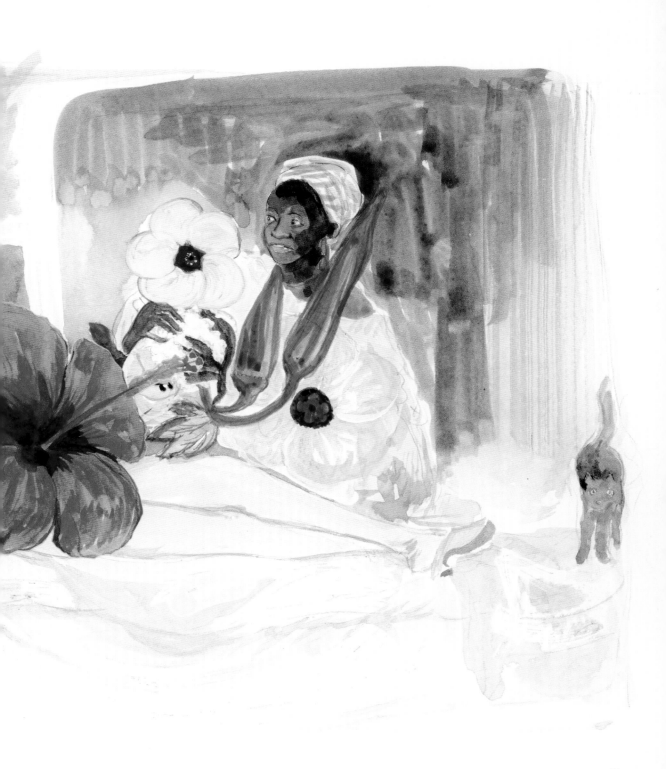

H IS ALSO FOR *HELIANTHUS ANNUUS*, OR, THE SUN-FLOWER. The sunflower, ordinarily so tall on its stout stem, has a large single flowerhead, a ray of yellow, as if mimicking the sun itself, that is usually modestly tilted downward as it follows the path of the light that the stable sun shines on our planet, Earth. This flower, so common to us now, is endemic (native) to the dry parts of the places we call Mexico, New Mexico, Arizona, and Texas. It was worshipped by some people (the Aztecs); the Hopi extracted dyes from its seed and also ground the seeds into a flour. The sunflower was introduced to Europeans by rapacious Spaniards and to Russia by Peter the Great. It is the national flower of Ukraine, where it is called *soniashnyk*.

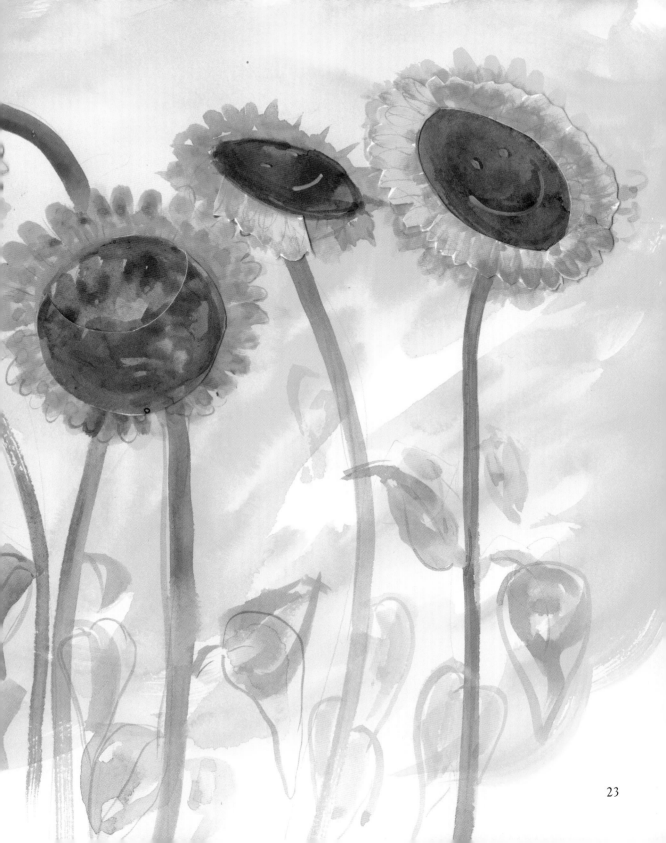

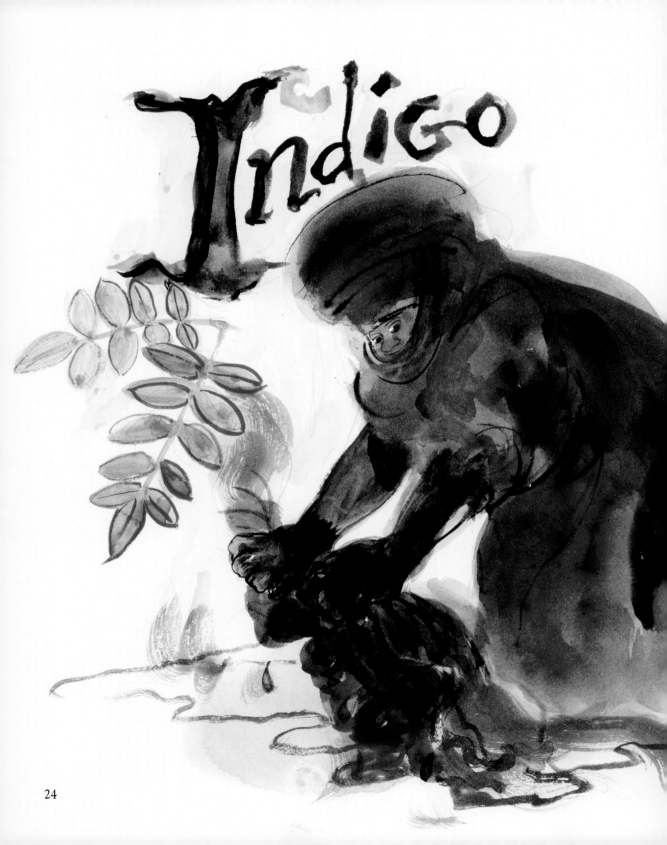

Indigo

24

I IS FOR INDIGO (*Indigofera tinctoria*). Indigo is a member of the pea family (*Leguminosae*), also native to the tropical area of China. Its exquisite blue color, used for dyeing, comes from its leaves and new stems, which when fermented produce a substance known as indican, which then is transformed into the dye known as indigotin, hence, indigo. It was introduced into the New World, as it was called, because of the European conquest of the Western Hemisphere, as a cash crop like sugar and cotton, eventually becoming an important part of the economy of France. In its time, indigo, which was grown in Haiti, produced more wealth for France than the entire East India Company did for England, and the Haitian Revolution, which freed the enslaved Africans, was so catastrophic to France's economy that it led Napoleon Bonaparte to sell Louisiana to President Thomas Jefferson.

J IS FOR *JEFFERSONIA*, a spring-flowering woodland plant that has only two members in its genus: *Jeffersonia diphylla* (native to North America) and *Jeffersonia dubia* (native to northeast Asia). It is a low-growing plant that appears in early spring, with leaves that are divided into two lobes, thereby giving the plant its common name, twinleaf, though the two lobes are not identical. It briefly bears a beautiful white flower, and then a short time later the entire plant disappears. The plant was named for Thomas Jefferson by his friend the botanist Benjamin Smith Barton, who may have suspected that our third president was a man divided into two parts that were not so much opposed to each other but not complementary either.

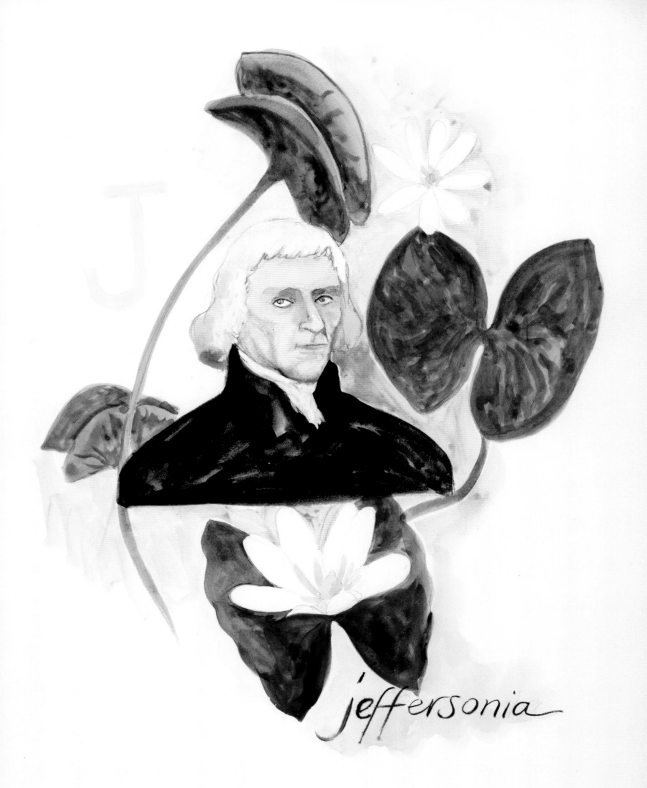

jeffersonia

K IS FOR KITCHEN GARDEN. The kitchen garden is the same thing as the vegetable garden—a place in which we grow food such as zucchini, pumpkin, tomato, watermelon, collards, kale, spinach, carrots, beets, beans, peas. But when we say we have a kitchen garden (or a vegetable garden), it is our way of reminding ourselves that we have—and can afford to have—another garden, one that is full of trees and flowers, arranged in areas divided by pathways and walls, and the manipulation of water into shapes that ordinarily would be found on a walk in the wilderness (ponds, lakes, waterfalls); and statues, grottoes, and even sometimes making seating arrangements solely to view other landscapes that are natural and far away from the garden in which we are sitting. That garden feeds and nourishes our souls and inspires us to think about "things": the little doubts we harbor deep inside ourselves, our

hatreds of others, our love of others, the many ways in which we can destroy and create the world and live with the consequences. In that other garden we grow mostly plants that are pleasing to the eye (roses, daffodils) and the nose (roses). In the Edenic creation story, the tree of Life (which is in the kitchen/vegetable garden) appears before the tree of Knowledge. "And the Lord God caused to grow every tree that was pleasing to the sight and good for food, with the tree of Life in the middle of the garden, and the tree of Knowledge of good and bad."

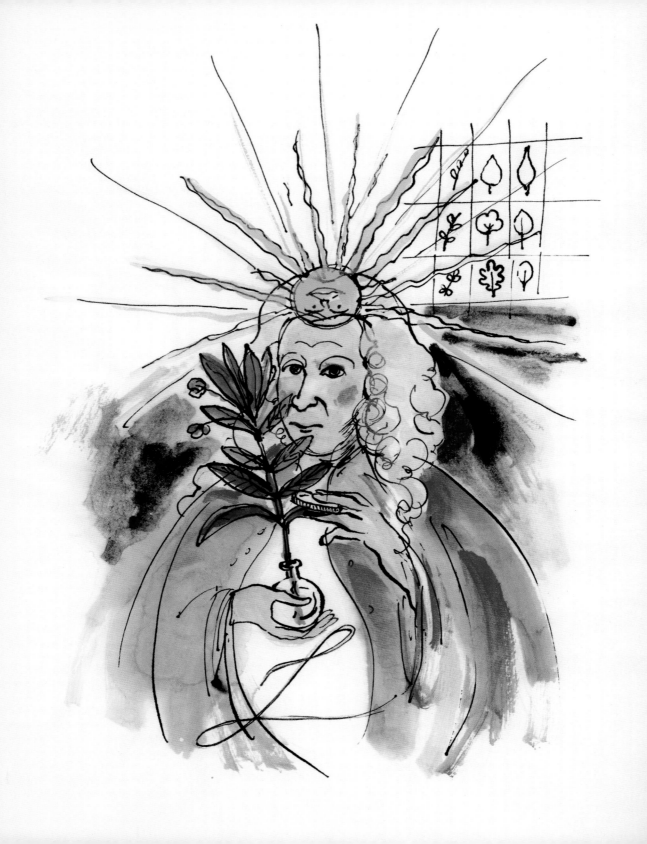

L IS FOR LINNAEUS. Carolus Linnaeus (or Carl von Linné, as he came to be known) is the Adam-like figure in the history of the science of botany. He was a doctor, but in the eighteenth century a doctor knew more about plants than she knew about the way the human body functioned. At that time, the same plants would be known by different names in different places. It was Linnaeus who came up with the classification system known as binomial nomenclature: genus and species. Genus indicates the family to which the plant belongs, and species indicates the specific aspects of the plant: an example would be if your family name was Gates but in the Gates family you are Skip. Latin was the common language used by educated people of many different countries, because the people for whom Latin was their native language had disappeared in the natural evolution of human beings meeting and destroying each other.

Linnaeus's family name was Ingemarsson, but his father is said to have adopted the name Linnaeus after a linden tree (*Tilia*) was found growing outside the family home, perhaps bestowing a prophetic legacy on his son. In Greek mythology, the linden tree is associated with Aphrodite, the goddess of Love.

L IS ALSO FOR *LIRIODENDRON* (*tulipifera* and *chinense*). The liriodendron is a large hardwood tree in the magnolia family (*Magnoliaceae*) and is most familiar to people who live in the northern areas of the American continent as the tulip tree because its flowers are almost identical to an ordinary tulip in color and shape, just the kind to give to a parent as a gift of appreciation for the love they have showered on you. It has only one relative: a brother/sister in the tropical area of China, an area at the same latitude as Cuba, that is called *Liriodendron chinense,* and there its leaves are almost twice the size of the one in North America. In the northern part of the Americas, it is well-known and was especially beloved by that great lover of plants (yikes! among other less pleasant things) Thomas Jefferson. He called this tree the poplar tree, though it is not in the poplar family at all. A tree he planted at his renowned Monticello still remains upright.

The liriodendron native to North America has been memorialized by Billie Holiday in a song called "Strange Fruit," about the murdered bodies of African Americans in the area where the tree was most native (the South), who were often hanged and strung up from its strong branches:

> Southern trees bear strange fruit
> Blood on the leaves and blood at the root
> Black bodies swinging in the Southern breeze
> Strange fruit hanging from the poplar trees[*]

*Lyrics by Lewis Allan

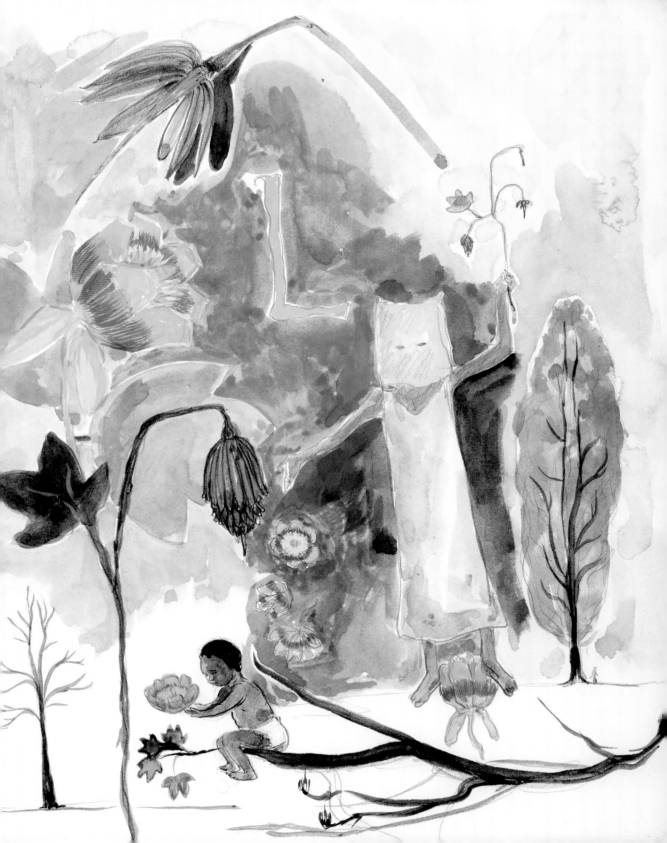

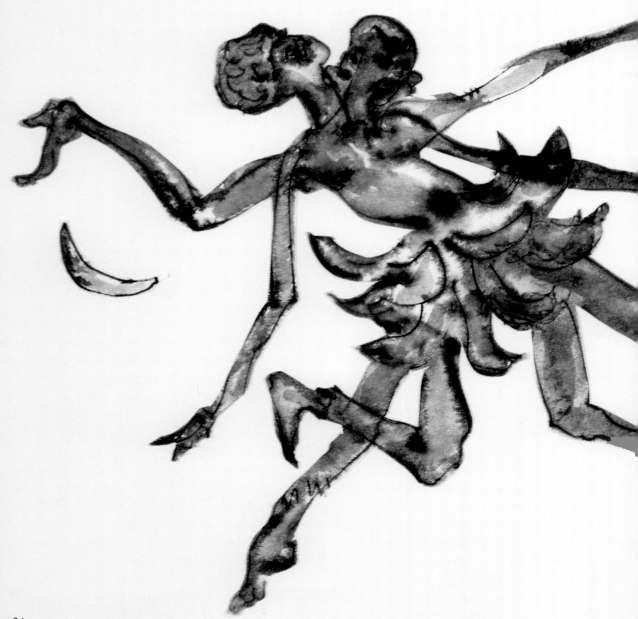

M IS FOR MUSA, which is the proper name for the banana (*Musa × sapientum* or *paradisiaca*), a monocot. The monocots are plants that emerge from their seeds with one leaf. The monocots include all the grasses, lilies, irises, sugarcane, rice, and countless other plants that we love. The banana is native to the tropical regions of Africa and Asia and was first introduced to the Western Hemisphere by Spanish invaders and Christian missionaries. Unlike cotton and sugarcane, it did not become part of the enslaved wealth-generating economy, but by the nineteenth century, as it became more familiar to us, it was grown on plantations in conditions not very far removed from the conditions imposed on the enslaved.

N IS FOR *NICOTIANA*, a member of the nightshade family (*Solanaceae*, which includes tomato and eggplant). Many of the species are used as flowering annuals that are quite beautiful in late summer in a flower garden. But the most famous individual of the species is tobacco, *Nicotiana tabacum*, from whose leaves cigarettes are made. As with sugar, cotton, and indigo, vast fortunes were created by enslaving Africans to grow tobacco on plantations, for, as with these three commodities, they are all suitable to tropical climates. The name *Nicotiana* "honors" Jean Nicot, a Frenchman who introduced the plant to France.

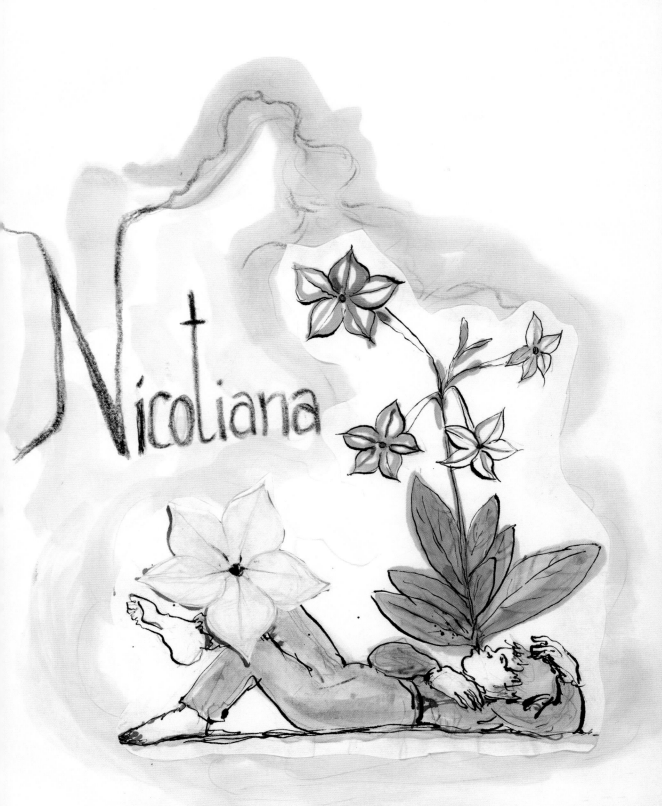

Nicotiana

O **IS FOR ORANGE.** The orange is a member of the citrus family and is properly referred to as *Citrus sinensis* because it originates from the part of the world we now know as China. The planet we call Earth seems to be on the whole indifferent to the names and characteristics we human beings assign to it: *sinensis, japonica, canadensis,* and so on and so on. The vegetable kingdom persists and will most likely do so when we are no longer here to name and identify it. The citrus family includes limes, lemons, and grapefruit, which are mostly native to the tropical parts of the world, though they can be found domesticated in places that have been designated as a "Mediterranean" climate, such as parts of Southern California. The grapefruit is said to be a sport of pomelo, which comes from New Guinea and presented itself in Jamaica, where the British had sent many plants to be part of the economy tied to the enslavement of Africans. A much-repeated idiom, "It's apples and oranges," is meant to illustrate a vast difference that exists between two objects or ideas: they do not naturally thrive in the same climate, except in the mythical Garden of Eden, where all things exist in harmony, no matter their difference. The African American patriot and writer Frederick Douglass made this observation when he was enslaved on a plantation in Maryland, U.S.A. "Colonel Lloyd kept a large and finely cultivated garden, which afforded almost constant employment for four men, besides the chief gardener (Mr. M'Durmond). This garden was probably the greatest attraction of the place. During the summer months, people came from far and near—from Baltimore, Easton, and Annapolis—to see it. It abounded in fruits of almost every description, from the hardy

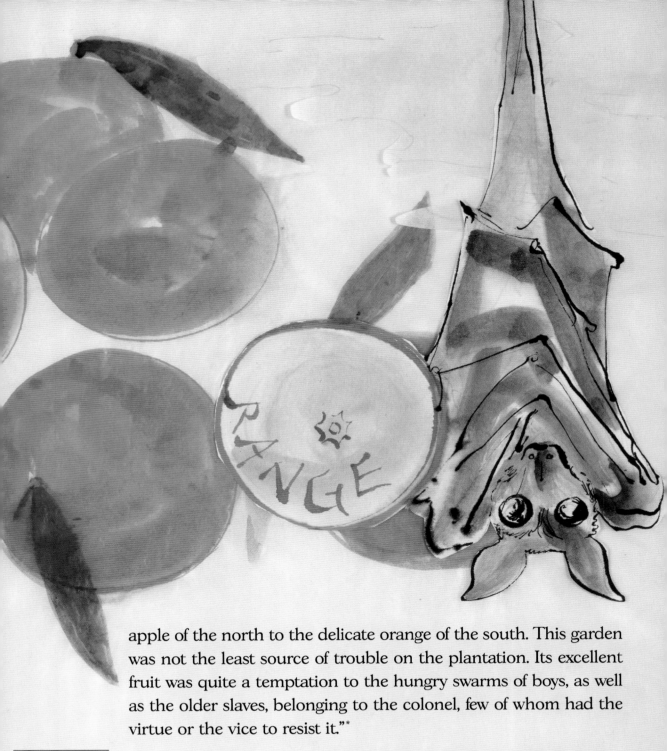

apple of the north to the delicate orange of the south. This garden was not the least source of trouble on the plantation. Its excellent fruit was quite a temptation to the hungry swarms of boys, as well as the older slaves, belonging to the colonel, few of whom had the virtue or the vice to resist it."*

*Frederick Douglass, *Narrative of the Life of Frederick Douglass, an American Slave* (Boston: Anti-Slavery Office, 1849), 15–16.

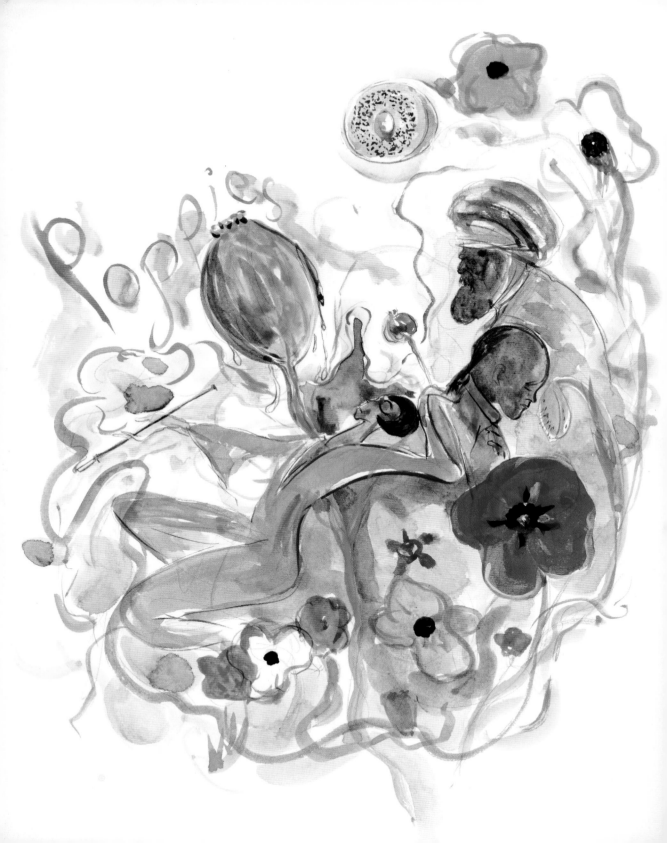

P IS FOR PAPAVER, which belongs to the Papaveraceae family, a family that is widely distributed throughout most of the temperate regions of the Earth. There is the Icelandic poppy, native to the subarctic; the California poppy, *Eschscholzia californica*; the Oriental poppy, native to Turkey and Iran; the blue poppy, *Meconopsis betonicifolia*, native to Nepal and Western China; the plume poppy, *Macleaya cordata*, native to Japan; Matilija poppy or *Romneya coulteri*, sometimes called the tree poppy because it can grow to a height of six feet, native to Mexico; and the most famous of them all, the opium poppy, *Papaver somniferum*, which is native to the Mediterranean region. Opium was used in ancient Greece and Rome for recreational and medicinal purposes, but when introduced to China, its use led to widespread addiction, and it was banned. In the mid-nineteenth century, the British fought and won a war with China because the Chinese refused to allow the importation of opium to China in exchange for European access to China's silk, porcelain, and tea. It would be as if Colombia and Mexico invaded the United States for the purpose of forcing Americans to buy cocaine and other addictive plants so they could have access to whatever it was the Americans had and they wanted.

P IS ALSO FOR *PROTEA*. The protea, a flowering, majestic, and magnificent beauty, is native primarily to southern Africa and is very familiar and much loved by the Black Indigenous people who share its landscape. The king protea (*Protea cynaroides*), the largest flowering protea, is the national flower of South Africa, and its image appears on many official documents, including the country's passports. The protea is said to be descended from a family of plants that were present in the Gonwandan period of the Earth's evolution, an era when the Earth was one continent, not broken up in pieces as now. The name "protea" comes from the Greek god Proteus, son of Poseidon, who was known for his ability to change shape, and the protea does present itself in a variety of forms and colors. Similar species related to it are to be found in Australia and New Zealand, areas of the Earth that, when viewed on a map, remind us that what we call Earth has a wholeness and completeness to it.

Protea

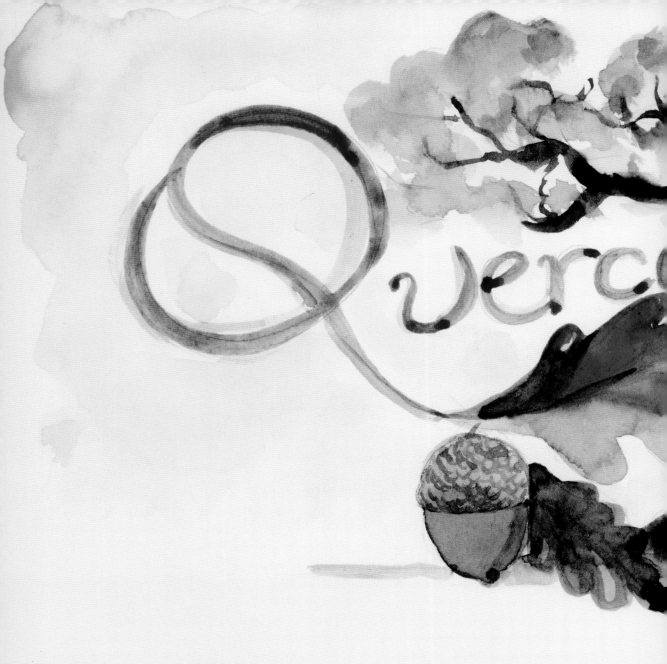

Q IS FOR *QUERCUS*, the mighty oak, a member of the *Fagaceae* family of more than five hundred species (including the beech and chestnut), which can be found in temperate and tropical areas. In some places it was identified with a god (Zeus); in other places it is a symbol of honor and wisdom. Its fruit, the acorn, provides food for mice and squirrels

(though it can be poisonous for cattle). Its wood is used for furniture and floors
and for aging whiskey and wine in oaken casks. The bark of the species *Quercus
suber*, cork oak, is used for making the cork that seals bottles of wine.

R IS FOR ROSE. This beloved and familiar flower belongs to the family *Rosaceae*. Its relatives include the apple, strawberry, loquat, raspberry, and almost all thorny-stemmed edible fruit-bearing plants. There are more than two hundred species of roses. Its flowers are mostly red or pink, very rarely yellow, and never black, and it occurs in places north of the equator. The rose is used in various religious ceremonies, as a symbol in war and peace, as a balm for dead heroes (in the *Iliad*, Aphrodite bathes Hector's body with the scent of roses), and as a sign to stay silent: if you enter a room and find a rose hanging from the ceiling, it means that everything said in that room cannot be repeated. It is *sub-rosa*.

Here is William Blake's "The Sick Rose":

O Rose thou art sick.
The invisible worm,
That flies in the night
In the howling storm:

Has found out thy bed
Of crimson joy:
And his dark secret love
Does thy life destroy.

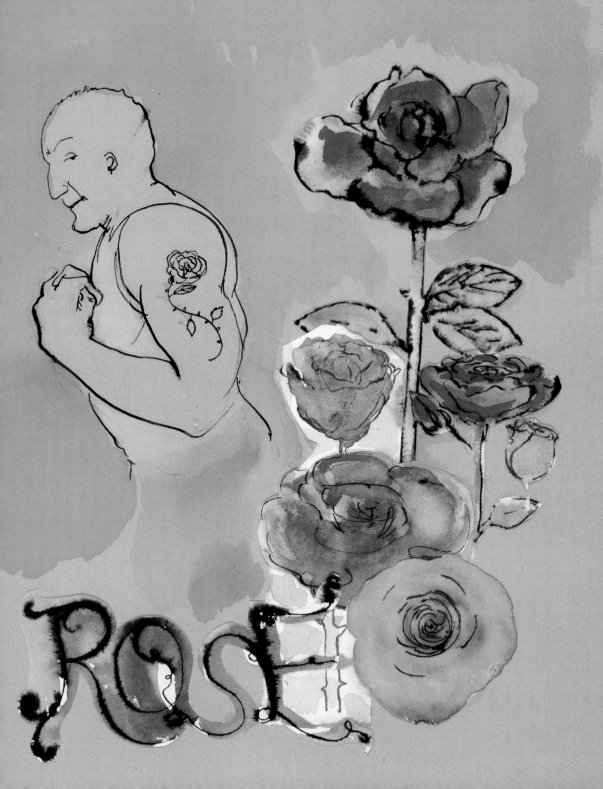

ROSE

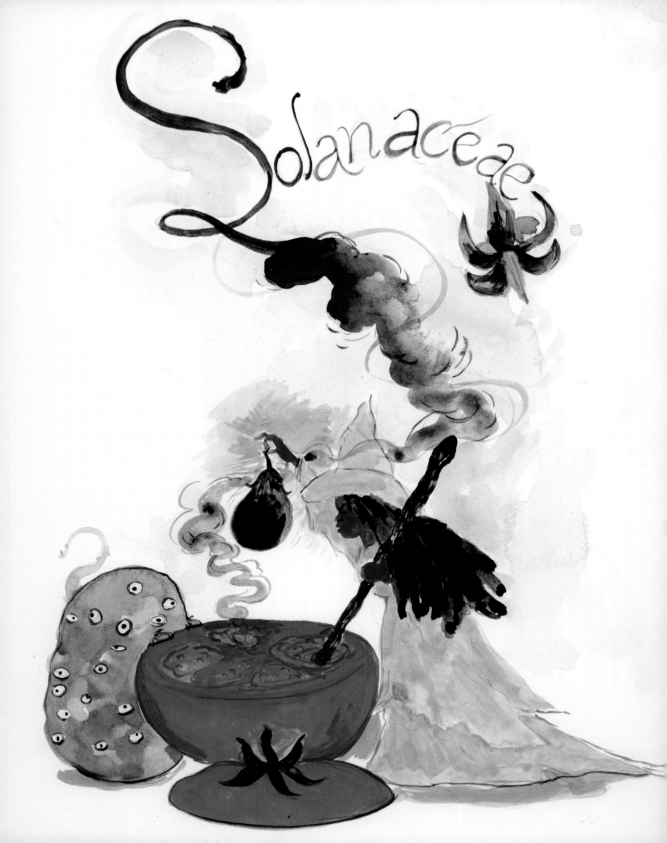

S IS FOR *SOLANACEAE*, a family of plants that includes the ordinary potato that makes french fries (*Solanum tuberosum*); the tomato (*Solanum lycopersicum*), which is the foundation for that wonderful sauce that is essential in a dish of spaghetti and meatballs; the eggplant (*Solanum melongena*); and many other flowering herbaceous and annual plants. Almost all the plants in this family are poisonous: the roots, the leaves, and flowers, with a few exceptions, among them the tubers of the potatoes and the fruits of the tomato and the eggplant, called aubergine in some parts of the world. The potato and the tomato are native to the Andes, that part of the Southern American continent that was ravaged by Hernán Cortés and Francisco Pizarro. The potato became so important to the European diet that a misunderstanding of its cultivation led to a deadly famine in Ireland. What is contemporary Irish history without the presence of the potato? What is Italian cuisine without the tomato?

S IS ALSO FOR SUGARCANE (*Saccharum officinarum*), a monocot, and a member of the grass family, native (or endemic) to the part of the Earth now known as New Guinea. It is the source of sugar, a food that is now regarded as providing no nutritional value whatsoever, and yet its cultivation and eventual exploitation by Europeans in the parts of the world that came to be known through the journey of Christopher Columbus from Spain to the Caribbean became the foundation of the wealth and power of the region we now refer to as Europe. It led to the wholesale subjugation and exploitation of many people who were occupants of the area of the world we call Africa. This lone plant, innocent of all the evil now associated with it (the enslavement of so many people living their lives in Africa), is now associated not with nourishment or beauty or pleasant memories but with despair and injustice. Many people in contemporary times are suspicious of sugar, and some parents will not allow their children to consume beverages that contain sugar of any kind.

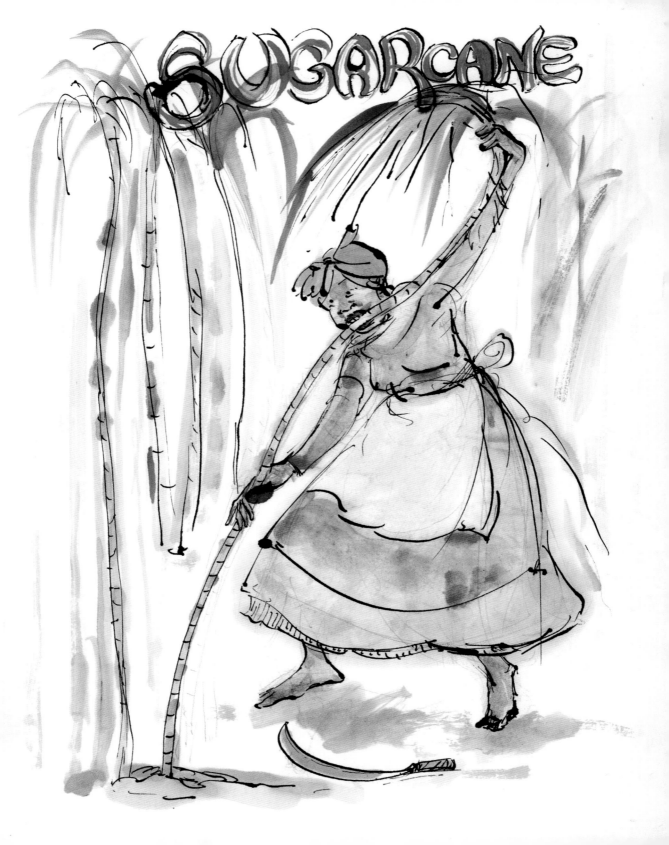

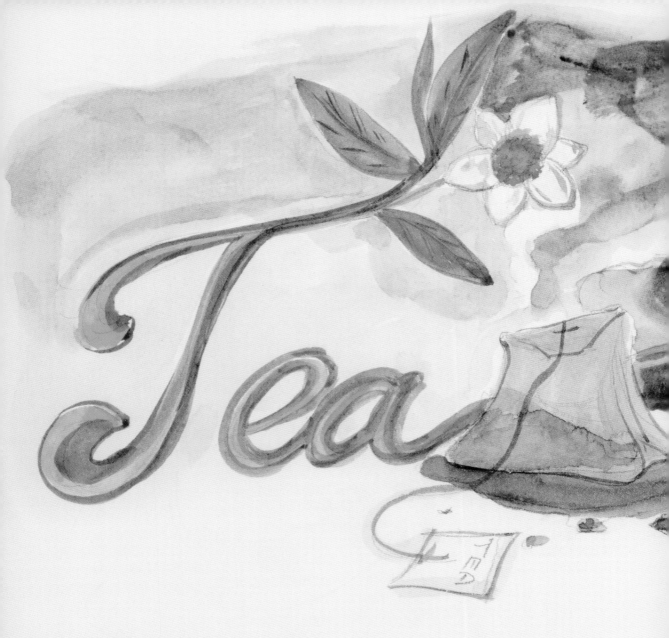

T IS FOR TEA. Tea, whose botanical name is *Camellia sinensis,* is the most important economic member of its family, the *Theaceae* family, which includes the trees *Stewartia* (*koreana,* native to Korea and Japan, and *ovata,* native to the Appalachian area of the United States) and *Franklinia* and the shrub *Gordonia.* Tea was first known in China, where *Camellia sinensis* is native, as a beverage.

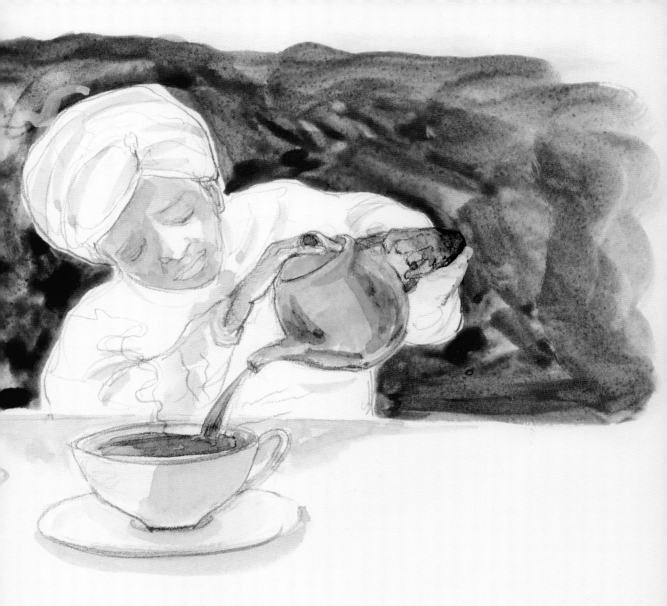

T IS ALSO FOR *TULIPA*, more commonly called tulip: the tulip, a spring-flowering bulb that is overly familiar to Muslims and Christians who live in the prosperous First World, is native to the mountainous part of the Earth that is designated as Central Asia (Kazakhstan, Afghanistan, Iran) and was cultivated by sultans and other people who could afford to grow plants only for their beauty in places such as Turkey. It was in Turkey (Islamic) that an ambassador representing the Holy Roman Emperor (Christian) saw the tulip and was so taken by its unfamiliar beauty that he immediately arranged to smuggle it out in his diplomatic bag and brought it to Vienna. Perhaps it was called the tulip because it looked like a turban, an article of apparel worn by people living in Turkey (the name "tulip" comes from the word "turban"). The appearance of the tulip in the Netherlands/Holland caused a sensation, as the people there live below sea level and so most likely were not used to flowers displaying exuberant colors (reds in particular). The Netherlands (or Holland) is not known for its exciting flowers; it seems to be covered with grasses. Even the Dutch iris is not native to the place that in Shakespeare is referred to as "the Low Countries." This flower, innocent of its presence in the drama of human joy and misery, the ups and downs in the life of an individual or a collective consciousness, rises up from the frozen ground displaying its glory. For those who are devoted to Islam, the petals form the word "Allah" and symbolize faith, prayer, and charity.

The tulip is the national flower of the Netherlands, but it is endemic to places far away from that land, which is occupied by the people who call themselves Dutch. The Dutch contribution to the garden is mostly grasses, promoted by the great plantsman Piet Oudolf, who has made grasses important and sensational in the contemporary garden.

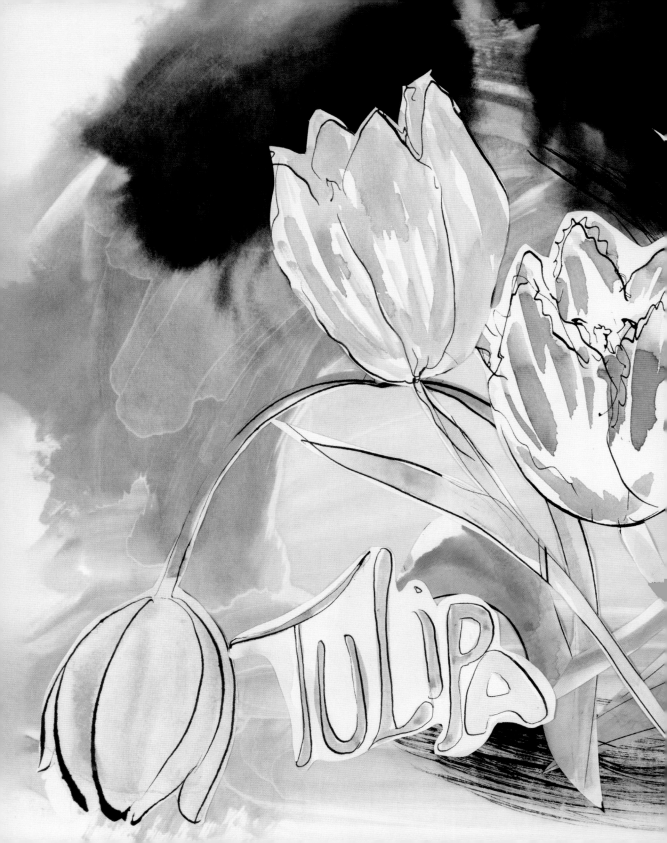

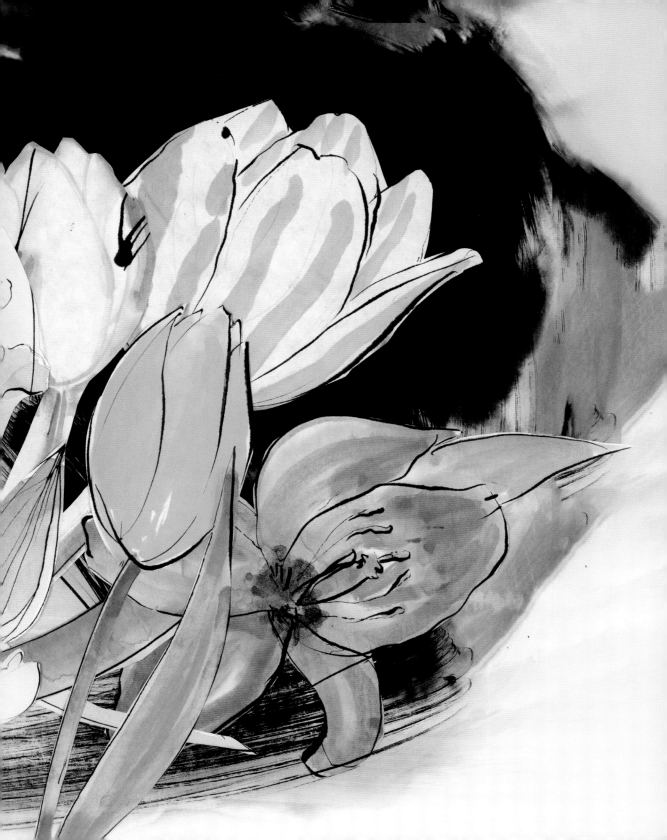

U IS FOR *ULMUS*, the botanical name for the elm tree. The elm is a large tree, growing up to a height of one hundred feet and with an equally enormous spread, found mainly in temperate and cooler climates in Central Asia, North America, and Europe. Its fame as a tree is widely celebrated in France, Greece, and Rome (it was the Romans who named the elm *Ulmus*). The North American elm (*Ulmus americana*, the state tree of Massachusetts and North Dakota), because of its impressive, elegant stature, was widely used to make the new American nation appear serious and old: it provided shade for the sidewalks of town streets. In our American narrative, the American elm is portrayed by the British American painter Benjamin West. The painting, titled *Penn's Treaty with the Indians*, shows William Penn, a founder of Pennsylvania, then a colony of England, entering into a treaty with the Lenape; the treaty used the words "openness," "love," and "one flesh and blood." The Lenape, taking him at his word, responded with the words "We will live in love with William Penn and his children, while the sun, moon, and stars endure."* William Penn is long dead, and the Lenape were dispossessed of their ancestral lands and made to seem strangers and wanderers in a world that wished and worked toward their complete disappearance. And yet, of the fifty individual states that altogether make up the United States of America, twenty-six of them bear the names of Indigenous people like the Lenape: Alabama, Alaska, Arizona, Arkansas, Connecticut, Idaho, Illinois, Iowa, Kansas, Kentucky, Massachusetts, Michigan, Minnesota, Mississippi, Missouri, Nebraska, New Mexico, North and South Dakota, Ohio, Oklahoma, Tennessee, Texas, Utah, Wisconsin, Wyoming.

The American elm is more or less extinct, having suffered from a blight that came from another part of the temperate region of the Earth.

*The Treaty of Shackamaxon, or Penn's Treaty.

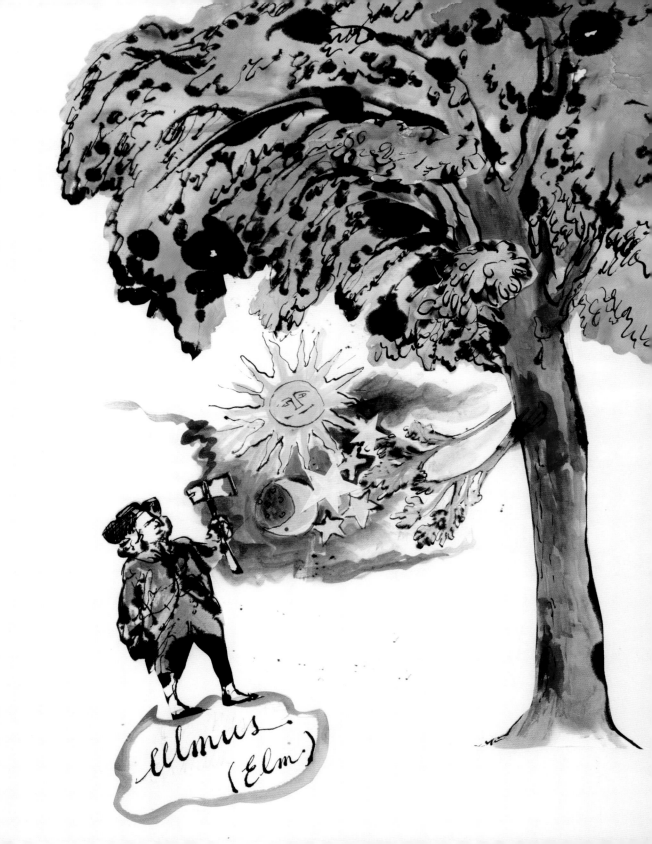

Ulmus.
(Elm.)

U IS ALSO FOR UTENSIL. Can you make a garden without tools? Yes, if you are God (the Garden of Eden), or a king (the Hanging Gardens of Babylon, made, they say, by Nebuchadnezzar and Semiramis), an owner of enslaved Africans (Arthur Middleton, a signer of the American Declaration of Independence), or a very rich man (Henry Dupont of Longwood Gardens, a man characterized as an industrialist). A gardener must use some tool or another to help her/him with the fine and hard work of making a garden, be it a garden of food or of flowers. Gardeners have made tools from the bones of animals and the branches of trees, and then with the discovery of bronze made some of the tools we are so familiar with today: the shovel, the rake, the fork, the trowel (a small hand-held shovel)—essentially anything a gardener finds necessary for making the ground they are bent over yield to their desire.

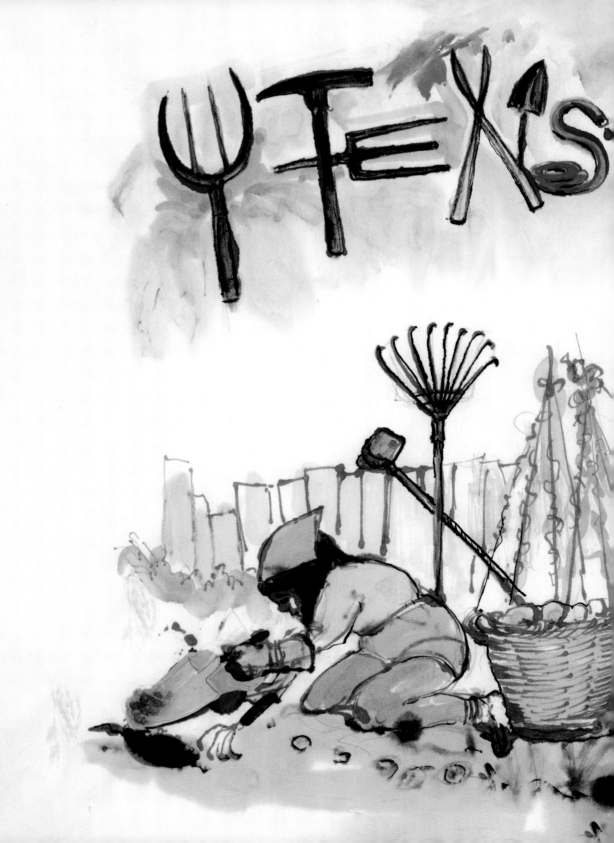

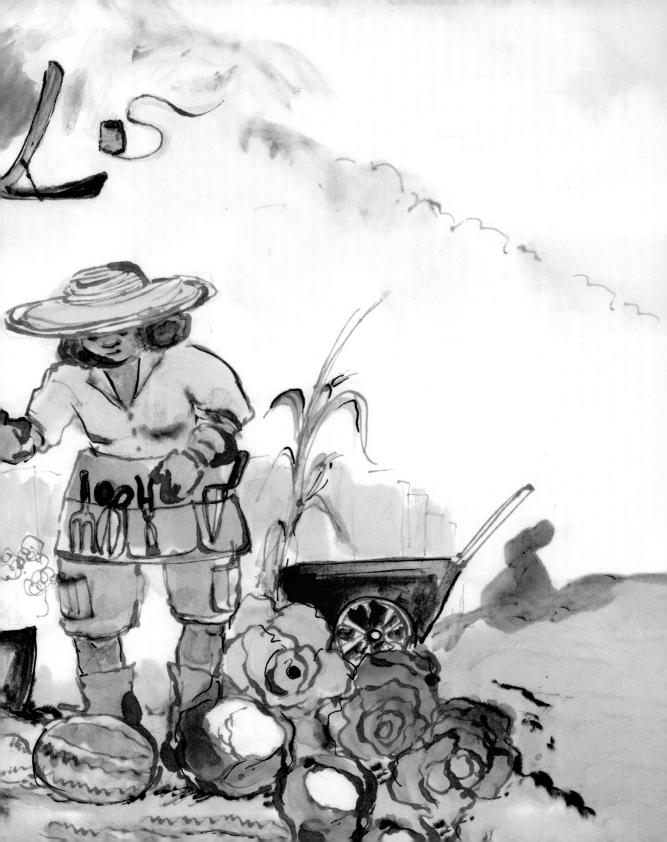

V IS FOR *VACCINIUM*, a genus that includes the blueberry and cran-berry. The low-growing, spreading blueberry bushes that can be found in Maine, especially, and are pleasing to come upon when hiking, with their small, refreshing sweet/tart-tasting berries, are called *Vaccinium angustifolium* (meaning the leaves are narrow). The blueberries that are good to eat and can easily be found in a supermarket and then used to flavor pancakes, pies, puddings, and ice cream are from the highbush blueberry, *Vaccinium corymbosum* (meaning the flowers of this species cluster together and form an almost flat head). *Vaccinium* can be found not only in North America but also in Peru and Ecuador and in parts of Central Asia.

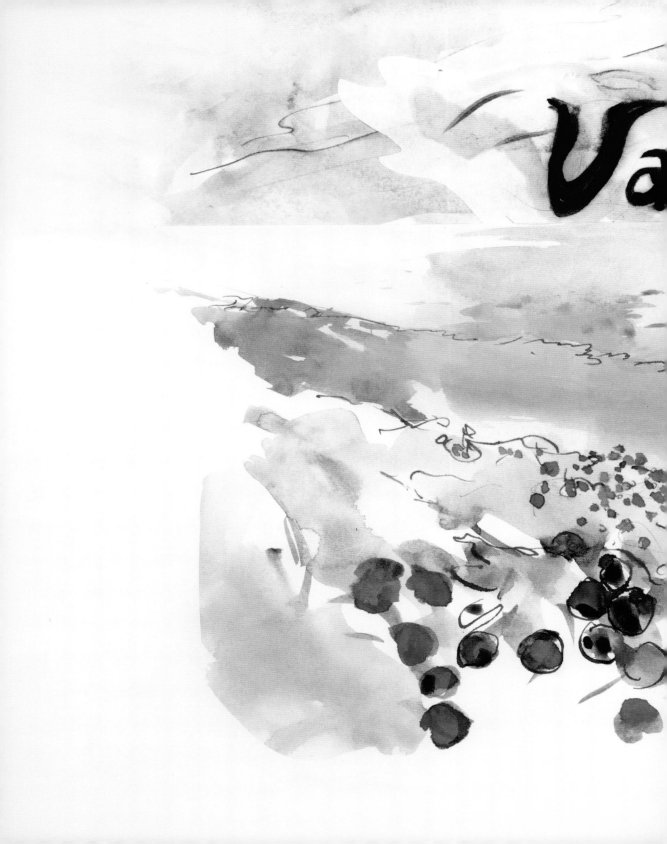

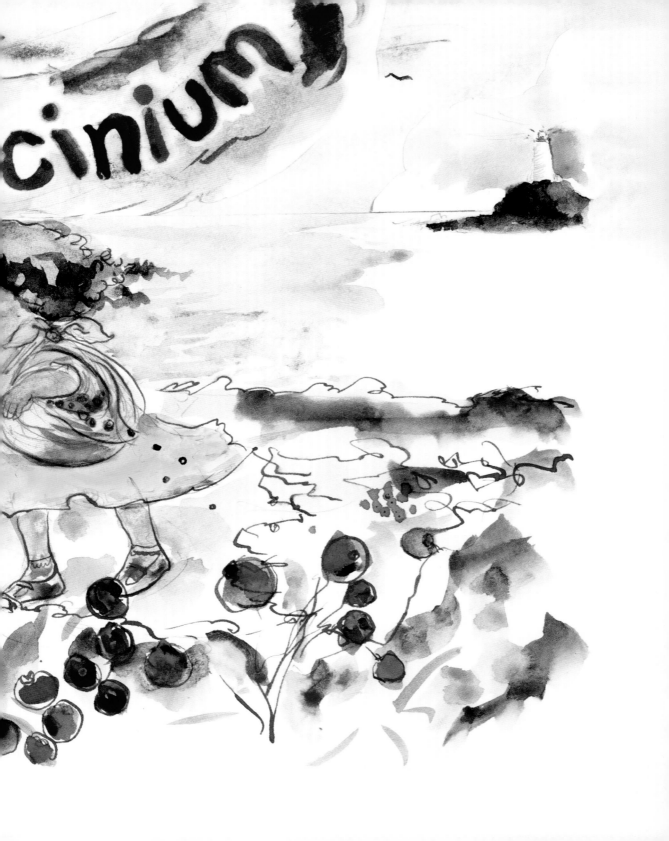

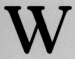

W IS FOR WATER.

> A river issues from Eden to water the garden, and it then divides and becomes four branches.
>
> —Genesis, chapter 2, verse 10

Water is essential to all plants growing in the garden, for it helps the plants' cells to take in food and distributes nutrients to the plants' various parts, such as leaves and roots. It is especially important in helping seeds to germinate. When there is an abundance of water in the garden, it is often put to decorative use, such as in a fountain or a birdbath. The four branches of the river in Eden intersect and form four quadrants, perhaps the first example of design in the garden. The names of the rivers of Eden are Pishon, Gihon, Tigris, and Euphrates.

W IS ALSO FOR *WARSZEWICZIA COCCINEA*, known as chaconia to the people of Trinidad and Tobago, where it is their national flower. The chaconia is also found on the mainland of central South America in Venezuela and other nearby places. Geologists know that Trinidad was part of the American continent, though it is now separated from it, and shares many features characteristic of that part of equatorial America. *Warszewiczia coccinea* was named for the nineteenth-century Polish orchid collector Józef Warszewicz; "Warszawa" is Polish for "Warsaw," which is the name of the capital of Poland. It is very doubtful that he ever went anywhere near Trinidad and Tobago.

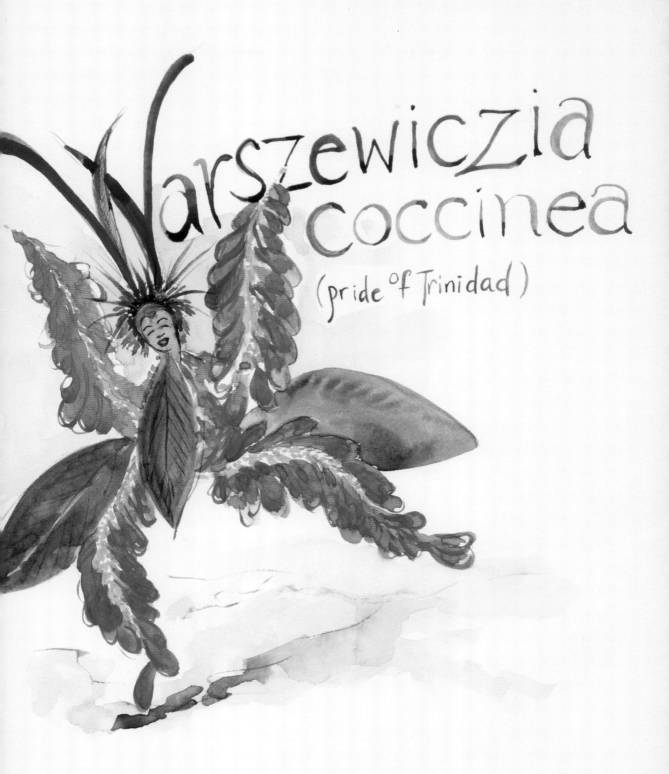

Warszewiczia coccinea

(pride of Trinidad)

X IS FOR *XANTHOSOMA*, a tuberous perennial from the Caribbean and Central America, known to me, this author, as dasheen, boiled and served with "salt fish." (Dried and salted cod imported from England were part of the intricate economy of the British Empire, and overfishing of this creature has led to an environmental crisis.)

Y IS FOR *YUCCA BREVIFOLIA*, commonly known as the Joshua tree. Like rice and all the other grasses, and the iris and the lily, it is a monocot, which means it has only a single leaf that emerges from the seed when it germinates. The alternative to this, two leaves emerging when the seed germinates, is called a dicot (mono = one, di = two). The Joshua tree is found mostly in the area of the North American desert called the Mojave, one of the five distinct desert environments in North America, and in the area we know as northern Mexico (in the Chihuahuan Desert). If a child accompanied by his/her/their parents were to take a hike through the area of the Joshua Tree National Park called the Mojave Preserve, she/they/he would see a forest of Joshua trees, growing densely and gloriously like a forest of oaks. The *Yucca brevifolia* got its common name, Joshua tree, from Europeans who were settling in that part of the United States, violently displacing the Indigenous population they met there. These settlers believed that this tree, with its unfamiliar form and arrangement of leaves and flowers, so abundant in the vast desert landscape, was a sign from God, giving them permission to continue their crime and claim the land that had previously belonged to the Indigenous people. It was not the first or the last time that a people called on the divine to justify an injustice.

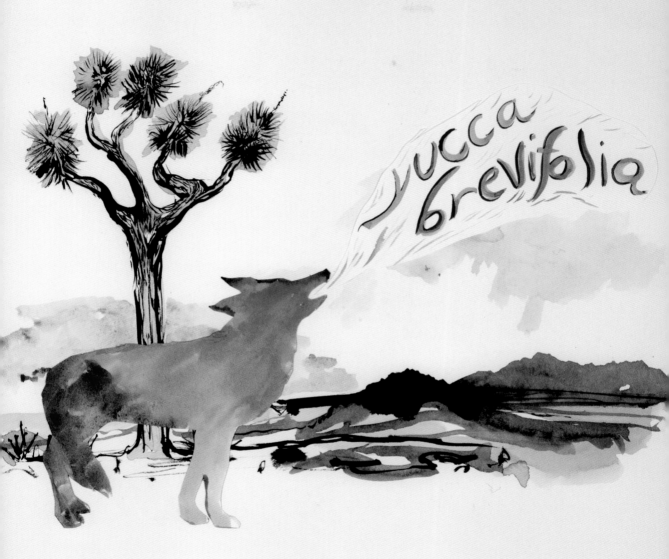

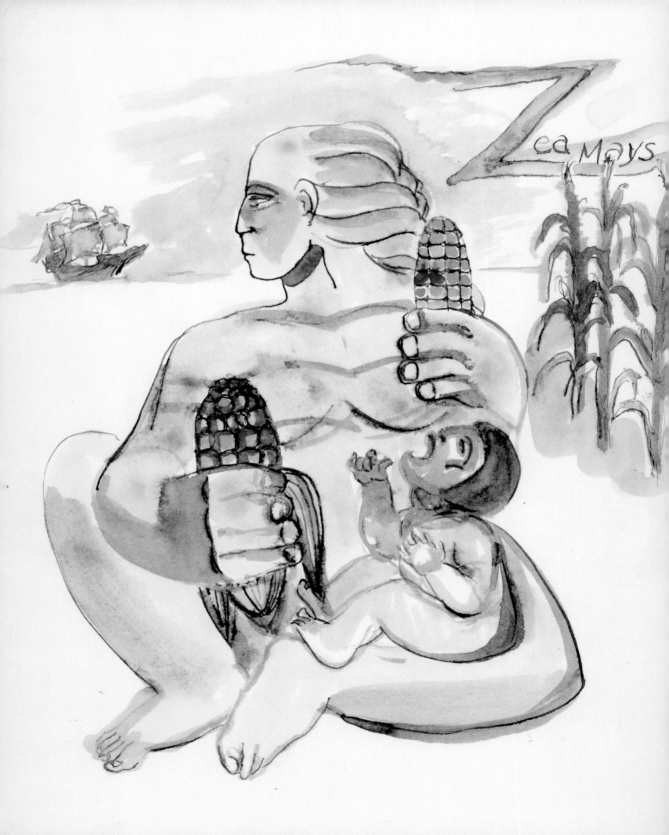

Zea Mays

Z IS FOR *ZEA MAYS*. Called corn in North America and maize in much of the rest of the world, it is sometimes treated as a grain when it is dried and ground into a flour (polenta), and when it is freshly picked and eaten it is a vegetable. Like all grains (rice, oats, barley) in the grass family, it was cultivated by the occupants of what we now call Mexico for thousands of years before Europeans arrived with their natural curiosity (curiosity being a part of what it is to be human) and thoughts of conquest and subjugation of the native inhabitants. Human beings, as they have migrated to and occupied various parts of the Earth, have always found nourishment in the grass (Poaceae) family. *Zea*, corn or maize, is grown all over the Earth by human beings, for food.

Zea is said to be the grass most widely cultivated for human consumption.

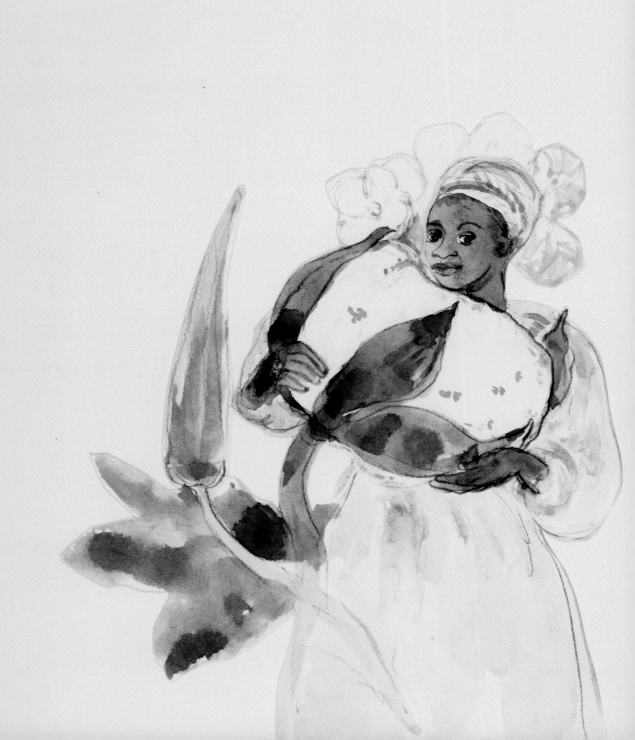

ACKNOWLEDGMENTS

With gratitude, I would like to acknowledge

Etz Hayim: Torah and Commentary

Annie Rosamond Shawn

Annie Richardson Drew

Frederick Douglass

Ian Frazier

John McPhee

The History of the Conquest of Peru and History of the Conquest of Mexico by William H. Prescott

Thomas Jefferson

Daniel J. Hinkley

The Journal of Christopher Columbus (During His First Voyage, 1492–93)

Captain Cook's Journal During His First Voyage Round the World

Travels of William Bartram

The Valley of Flowers by Frank Smythe

Elaine Scarry

Carolus Linnaeus

Ann Warner Arlen

Botanical Latin by William T. Stearn

The Oxford Companion to Gardens (edited by Geoffrey Jellicoe, Susan Jellicoe, Patrick Goode, Michael Lancaster)

The Standard Cyclopedia of Horticulture by L. H. Bailey

Joseph Dalton Hooker

Joseph Banks

Harold Wallace Shawn

—JAMAICA KINCAID

I'd like to thank my daughter, Octavia Bürgel, for keeping me young and my partner, Ari Marcopoulos, for keeping me going. Additional thanks to Allison Calhoun and Justice Thomas from my studio for their assistance on this project. Special thanks to Hilton Als for bringing Jamaica and me together to create the very special book you hold in your hands.

—KARA WALKER

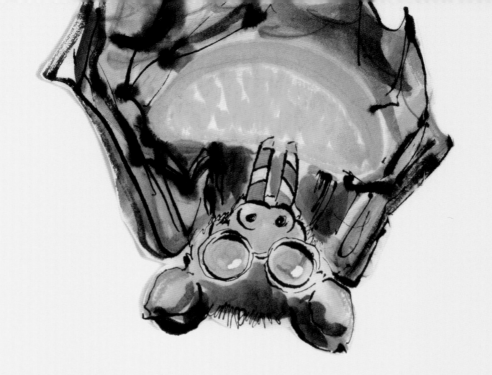